Praise for
Poems 1980–2015

'These poems from three and a half decades constitute European poetry in the mask of English, and they are a unique addition to the Capital of Letters.' —*The Irish Times*

'And it has to be said that the conversation extended throughout these poems; on how to be a poet, on what is a poem, on what can a poem handle – as well as the poems themselves – places O'Loughlin deservedly within the canon of contemporary Irish poetries.' —*The Dublin Review of Books*

'O'Loughlin directly links back to Dublin's first truly great Dublin poet, James Clarence Mangan. Mangan was not a keeper but a breaker of tradition, the ultimate nonconformist and dissident. O'Loughlin has inherited this mantle of being a maverick writer of ideas rather than a peddler of local colour. Few writers have written so accurately and so unsentimentally about Dublin, in a tone equally at home and displaced in all cultures.' —*The Sunday Business Post*

'A writer or poet, Cyril Connolly once said, should be aware, as far as possible, of his or her 'latent curve of development'. That curve in O'Loughlin, through the angers and distractions of the years, looks increasingly like the circle Kavanagh describes, returning upon itself, but knowingly.' —*Poetry Ireland Review*

Photograph © Ellius Grace

MICHAEL O'LOUGHLIN was born in Dublin in 1958 and studied at Trinity College Dublin. He has published six collections of poetry, including *Another Nation: New and Selected Poems* (1996), *In This Life* (2011) and *Poems 1980–2015* (2017). He has published numerous translations, critical essays and reviews, as well as writing screenplays and journalism. His poems have been widely anthologised and translated. He has been Writer in Residence in Galway City and County, Writer Fellow at Trinity College Dublin and was UNESCO City of Literature Writer in Residence in Prague in 2017. From 1980 to 2002 he lived in Barcelona and Amsterdam, and now lives in Dublin with his wife, the singer and writer Judith Mok. He is a member of Aosdána, the affiliation of artists in Ireland.

LIBERTY HALL

For Judith and Saar

LIBERTY HALL

Michael O'Loughlin

NEW ISLAND

LIBERTY HALL
First published in 2021 by
New Island Books
Glenshesk House
10 Richview Office Park
Clonskeagh
Dublin 14, D14 V8C4
Republic of Ireland
www.newisland.ie

Copyright © Michael O'Loughlin, 2021

The right of Michael O'Loughlin to be identified as the author of this work has been asserted in accordance with the provisions of the Copyright and Related Rights Act, 2000.

Print ISBN: 978-1-84840-797-8
eBook ISBN: 978-1-84840-798-5

All rights reserved. The material in this publication is protected by copyright law. Except as may be permitted by law, no part of the material may be reproduced (including by storage in a retrieval system) or transmitted in any form or by any means; adapted; rented or lent without the written permission of the copyright owners.

All effort has been made to seek permission to reproduce images herein. Any breaches, omissions or errors should be made known to the publisher directly.

A CIP catalogue record for this book is available from the British Library.

Typeset by JVR Creative India
Edited by Djinn von Noorden
Cover image by Colman Doyle and colourised by John Breslin. Model Linda O'Reilly is admired on Winetavern Street, Dublin. Courtesy of the National Library of Ireland and with help from Irish Academic Press | Merrion Press.
Cover design by New Island
Printed by SPRINT-Print, www.sprintprint.ie

New Island received financial assistance from The Arts Council (An Chomhairle Ealaíonn), Dublin, Ireland

New Island Books is a member of Publishing Ireland.

Contents

I
The Names of the Rat	1
What I Had Overlooked	3
Days of 1982	5
To Those Who Come After	6
Summer in Andorra	8
Sleeping in Prague	10
Leonard Cohen	13
A Dutch Life	14
Muse	16
For Saar on Her Sixteenth Birthday	18
Deutschland 1975	20
The Hyperlocal	22
Rue des Irlandais	24
Bastille Day, Labastide, 2007	27
Beuys	31
Falling	32
The Angle of the World	34

II
Transpontine	43
Liberty Hall	51
Appendix: Meridian	69
Acknowledgements	79
Image Credits	80

I

The Names of the Rat

I'm holed up under Robert Emmet Bridge.
I know who he was – an ancestor lapped his blood
as it ran downhill from the butcher's block
outside St Catherine's Church –
a meal to remember.

Then came the years of the Great Feast
when no one ever went hungry.
We acquired a taste for human meat –
strap me to your chest
I'll eat your heart out.

It's a rare treat now – my diet is more pedestrian
and amphibious. But in summer,
when hipsters hug the canal bank
I stuff myself with hummus and sushi.
In winter it's back to worms and slugs

And fighting the swans for scraps of stale bread
sulky cygnets and cranky old gits
a bang of whose wing would break your back
while the cormorant puts himself up on his cross
and poses for photos.

My giant cousin, the otter, passes by,
taking the watery metro home
to his river. There's a one-legged bloke
whose name I don't know.
I give him a wide berth –

He thinks my name is lunch.
I know the name you give me –
when you say the word you bare your teeth
in weird defensive mimicry.
But that's not who we are.

My true name is whistled down through our cells,
a covenant carved in our skull's catacombs
unspoken, unutterable, but borne before us
like an invisible escutcheon
to shield us from your hatred.

You want us not to be.
You plague us with your poison.
It gleams yellow in our children's eyes
as we watch them die.
But this land was promised us too.

Like you, we come from the boats
to settle in this holy ground.
Now, we live in each other's shadow.
We breathe the same air, drink the same water,
when you cut us, we bleed with your blood.

What I Had Overlooked

One day, just like that,
God disappeared.

I was twelve or thirteen years old. It wasn't just God, but everything. The world had come to seem like a crudely made stage set. I stared at the people on the TV screen, they looked like marionettes. I felt like some kind of messenger from the future. That sounds pompous, or even slightly mad, but it was more a sensation that none of this could last, it was all rubbish, and I was just waiting for it to end. And then our real lives would begin.

I did not know
it would take so long.

And yet.

Brecht or Benjamin could have told me, but I had worked it out for myself, from watching the apocalyptic sunsets above the glistening granite of St Canice's Church. Everything was telling me: the churned-up mud of the unfinished parks, the stains of rain on the front of the concrete houses, the empty night streets humming with yellow violence, the unreachable mountains in the distance. It was like some angel had whispered Goethe in my ear: 'I see no trace of a spirit, everything is facade.'

And yet.

When I went to university I found the other students unbearably undergraduate in their belief that they could learn something there. I avoided the actors and literary tyros, I thought them already redundant. No, I preferred the company of apprentice

politicos, they seemed to share my sense of time, my hatred of the teleological, the awareness that every moment is the rotten door through which a messiah can enter, that the future, in fact, is already here: Pleased to meet you! I must have been insufferable. As they were.

And yet.

'The examined life is not worth living' was my motto. And Jacob Frank: 'A soldier has no morality.' I never considered not leaving. It wasn't emigration, but returning to the homeland, the world out there. If I ever came back, it would be like Wolfe Tone, at the head of a shining army, part of a universal plan, I would be out in the bay on the ships waiting for the weather to lift so we could unload Liberty, Equality, Fraternity, onto the hungry soil.

What I had overlooked:

– the ineluctable modality of everything which is
– the unforgiving unvirginity of the soul
– that the ships will
 always be massed in Bantry Bay
 waiting for the weather to lift
 but the weather never lifts.

And yet.
And yet.

Days of 1982

For Bernard Loughlin

I came back from Barcelona
with cowboy boots, a sheepskin coat
and a book by César Vallejo.

My sister gave me a scarf she'd knitted
from our mother's scraps of wool.
It made me look like Doctor Who.

Tony Gregory was composing sonnets,
red-brick, three-storeyed poems
for people to live in.

I went up to Annaghmakerrig
and fished for pike
in the sullen lake.

Mary Loughlin fed us like kings.
Bernard poured the wine.
It felt like our inheritance.

The painters I knew were neo-expressionists
my dreams were filled with murky blue light.
I thought I might give Berlin a shot.

Snug in my coat, I strode down Grafton Street,
the future stashed inside me
like a payload of kryptonite.

To Those Who Come After

No good looking to us for answers –
we were hardly here,
the traces we left
more substantial than we were.

Do not mock us!
Despite it all
we are more real than you will ever be.

Though we passed like spectres
through the light of our screens,
though we ran through avatars,
shaking off skins
like a snake made of air.

Tired of being ruled by men like ourselves
we set off for the West,
where we would lie entombed
in pyramids of light and simulacra.

We were alone
with all the memories of the world
and all its fears.
It was too much.

We are no comic-book heroes –
our one superpower
the ability to negate ourselves
though in our feeble, distant dreams
we were destroyers of worlds.

But now we know
that the light of a thousand suns is nothing,
barely a flicker in the dark.

The thrum and burst
of a thousand warheads
barely a fleabite
on the arse of the cosmos.

If you come after
you will know all this already.
I have nothing to add.

Summer in Andorra

He lived with a young hairdresser from Hamburg called Elke. She had a spiky-blond punk hairstyle and, wearing only her leopard-skin bikini, would climb out of the window of Joel's top-floor apartment and swing, monkey-like, over a thousand-foot drop, up onto the roof to sunbathe. She was such a terrifying driver that none of us would get into her jeep in the evenings, when we headed off to pogo to vintage punk in nightclubs in distant, barely accessible valleys. She would speed around bends on single-lane roads clinging to the side of the mountain, where the only thing between you and the sheer drop was the little cross commemorating the last driver who had gone over.

We picnicked on barbecued rabbit near deserted ski resorts, where the lifts hung motionless in the scorching air. I kept thinking it was a metaphor for something, but couldn't quite figure out what.

Joel Manfredo, to give him his name, came on like a benign old hippy, in boiler suit and neat grey ponytail flopping over it. He was a dealer in precious stones. One night he took us down to his walk-in safe in the basement. There were little plastic pots of gems everywhere and as I sank my hands into cool pools of sapphires and turquoise, I asked how he got into the trade.

'It was chance really. I had the contacts in South America and the Far East. At one time I was the only one allowed into Burma, so I started to bring out rubies.' 'What kind of contacts?' I asked. 'Oh, old boys from my school. Most of them live in different places all over the world now, but we keep in touch.'

Despite the hippy mannerisms, he had that unsleeping watchfulness you often find in people who have been in the military

– or in prison. And alcohol exaggerated it. Late at night, as we sat in his apartment drinking Spanish red wine, he talked, and it seemed as if his back grew straighter, his head larger. I asked him if Joel Manfredo was his real name. He looked at me as if I was a bit slow: 'It's my Legion name.' Then he told me his real name, and how his friend had tried to kill him recently. His friend was an arms dealer based in Bangkok, where he lived in a dilapidated villa surrounded by an overgrown, jungle-like garden. After some heavy drinking, they played a game with bayonets. They had to track each other through the undergrowth and try to stab their opponent. Joel lost. His friend pounced on him from behind, and in frustration at not being able to sink his blade in Joel's back, had battered him with the hilt of the bayonet. 'He was always a killer. When we were in school, he killed one of our classmates. I don't remember why. I suppose it was the kind of thing expected of us.'

Then he told me about the school. It had been a special school in Prussia for the children of high-ranking army officers. '*Quatsch*,' said Elke, who was painting her toenails bright pink. 'War-war, yackety-yak.' Joel ignored her, stood up and left the room, returning with a photograph, which he laid before us.

The child with the shaven blond head in the photo was recognisably him alright, though instead of dungarees he was wearing a little black uniform. 'In February 1945 the Red Army was approaching Königsberg. They sent us out to fight the Russian tanks. After that it all gets hazy …'

Sleeping in Prague

After Kafka

Torturers know this. Keep us in light
and we shrivel like flowers –
keep us from sleep and we drown
like fish in the air, we sway and flail
like sailors on land, like astro-
and cosmonauts walking in space
cut off from the mothership.
With methadone and Benzedrine
the Wehrmacht tried to conquer
sleep and Russia …

At the end of the day in Prague
we stand in ragged lines in Anděl,
earthlings waiting for capsules
to shoot us up into space.
Tram and metro, taxi and bus
convey us aloft like sacrificial victims
to Inca pyramids on the hilltops –
the housing estates, *favelas*,
siedlungen, *cités* and *sídliště*, to sleep
stacked like slaves in a slave ship.

Our curious intimacy ... we can but do not speak.
My shipmates, my neighbours
regard me with indifference,
resentment, or even benevolence.
At Barrandov the supermarket lights
lure me in, last watering hole before the journey.
The apartment block creaks like a ship in the wind,
a straggler shouts out in the night
and we set off together, to sleep
without hope, to wake without pride.

In the morning I hear my comrades return,
their dogs' joyful welcome whining.
They loose their surplus liquids,
salute the day with coughs, or,
before alarms go off, engage
in regulation copulation. Stilettos
stab the parquet, and a voice is warming up
for tonight's performance of *The Magic Flute*.
The tantric masseuse's Indian bell
starts to jangle ...

But where have we been, my hearties?
It's just like Kafka said, it's a harmless affectation,
an innocent self-delusion, that we live in houses,
sleep in beds with duvets, all of it no more
than doors chalked by children
onto a brick wall. When we close our eyes
we return to a place we have never left,
gathered together as we always were
in an open camp in the desert, millions
of us, billions, a horde, a people, exhausted

under a cold sky, we drop where we stood
onto cold earth, our legs grown meaningless,
and now our head is on our outstretched arm
we face the ground at last, and we are home.
O save us from air strike and sabre-tooth tiger,
the secret policeman at the door –
at the edge of the camp, a signal fire
and beside it stands the watchman.

Leonard Cohen

You were our Man.
Your redemptive voice found us on the lost suburban streets.
You were the wicked agony uncle.
You were, like us, full of contradictions:

- tuneless songster
- romantic ladies' man
- cool Canadian
- shy rocker
- pop-star poet
- Jewish Buddhist
- gloomy optimist

You saw the future and it was murder.
The muse stretched out her hand and you took it.
You danced on medical marijuana to the end of time, you slipped out through the crack in things to meet the light of the Shekhinah.
And now King David has played for you the secret chord, which restores the broken world.

A Dutch Life

His father died in the War (not a Resistance hero,
just picked up one day and randomly shot),
so his childhood was hunger, fear
in the streets, and the Hun. But
the architecture was untouched. Most days
of his life he walks through Amsterdam South,
a utopia built for the poor, squatted by the rich.
After the War, Europe was one big mattress
so Remco Campert said, and he got his share.
(Now he sometimes meets those girls' grandmothers
in De Kring, loud with lipstick and nail polish
and he is tender and sentimental with them.)
He spent a lot of time smoking, in thick, dark overcoats
in freezing studios with painters hysterically
discovering pink and red and yellow.
Every day he ate cheese and bread with slow relish.
And so the Fifties passed, with children
and Reconstruction and the brave new dawn.
Why did it all have to be so grey? By the Sixties
he had learned to wear white suits, and his
favourite colour was the rainbow.
Good times, American girls, he smoked a lot of dope
but always returned to chilled jenever, preferably
drunk in the warm brown murk of Oosterling,
where his father had once held court.
He loved the first sly crackle of ice in the air,
he looked forward to the acrid, fat *zuurkool*
(as in the winter he thought of mussels
steamed in the pot, girls in spring dresses).
He did his bit, wrote his books; his column,
wry and sharp, was popular with the young
who sometimes came, blonde and thin,

to sit on his bed and comb his long grey locks.
There was a wife somewhere,
and children, but he lost them in the harsh Eighties.
Still, these days they're all friends again,
he summers in France in his daughter's house,
the grandchildren call him by his Christian name.
Now he has had a lot of wine
for lunch; as he sways in the hammock
in the shade of the mulberry tree
he dreams of Frisian skates strapped to his feet.
Seven years old, weightless,
he follows a silver road through the frozen polders,
so alone, nothing between him
and horizon, no sound
but the scrape of steel on the ice
as he leans forward into the light

Muse

'Goddess,' the nimble-witted Odysseus replied, 'it is hard for a man to recognise you at sight, however expert he may be, for you are always changing your disguise.' –Homer, The Odyssey

You're hard to recognise, bitchface
even for one astute as me.
At your service, as always
but I am not your numpty.

I hate how you're constantly shifting shape:
was that you I saw shuffle down Glenageary Road
that sulky camogie-playing nymph
soft belly stuffed with junk food?

Or the Russian girl one night on the Bloedstraat
in pink bra and platform boots, arms brightly inked
who, berating a punter with a baseball bat,
turned to me, and winked?

I think you were that ancient, head-scarfed Berber woman
squatting in a corner of the hospital ward
who brought me fresh mint tea, her dry brown hand
wordlessly anchoring me to earth.

You bobby dazzler, you tent show queen
blonde, brunette, ginger and dyed.
Get down off your horse, Miss High-and-Mighty,
why do you feel the need to hide?

Sure, you were raped by a clubfooted blacksmith –
oy Goddess, we all have tsuris, even you.
Eternally messed around with
by the gods? Me too, Princess, me too.

In all those years of wandering abroad
I was only sure it was you the once,
when the bus stopped to let you aboard
and I, a teenage pilgrim in France

Half asleep, caught a glimpse of your profile
drawn taut as a ship's bow figurehead,
saw your feet in glistening sandals
and snaking down your back, the tight blond braid.

Tacking through the wolf-haunted gorges of the Tarn
a few seats behind you on the bus
I'm sitting up straight, expectant, willing you to turn,
but you don't. And I never see your face.

For Saar on Her Sixteenth Birthday

Like the head of Orpheus
bobbing along the Bosporus
we finally came to nest in the Pera Palas
and slept in rooms vacated by King Zog
to dream of palaces lost
and kingdoms to come.

From our balcony we looked down
onto waste ground occupied by families
who sat quietly on abandoned sofas
amongst the bushes and rubbish
watching a TV linked to overhead cables
and we marvelled at how
the heart wrestles a home from the air.
You gave them all the money you had
and the concierge stopped me in the hall
to say: your daughter is a princess.

We crossed the Bosporus with old John Freely,
another of Sabbatei Sevi's mad Paddies.
'It's just like Amsterdam West,' you sneered,
the black T-shirt of your Irishness
already grown into place, already preparing
for your two years' strike of silence,
refusing to speak your mother tongue.

On the quayside we bought water, and *boreki*
and ate it sitting on the messianic stones
of the Dönmeh graveyard. How many homes
have we had since then?
Flimsy shelters of paper and fur
falling apart at the wolf's first puff,

to leave us shimmering like a hologram
in the hateful Dublin air.

Now we have returned against our will
to put our heads once more in the Tiger's jaws,
paying a king's ransom to live in a duke's stable,
Mahon evicted, Hartnett dead, and you resolved
never to leave the island again.

In New York we saw an old *chabadnik*
on West 47th Street,
carrying the weightless load of his diamond certainty,
almost floating along the pavement
like a living man moving through the kingdom of the dead.
His gaze passed through us to fix on you,
assaying and assessing, like a Traveller
at Ballinasloe, eyeing a piebald pony

and I thought of how you took
your almost first steps
on the icy cobblestones of Prinsengracht
where we met old Mrs Sarphati,
who bore her daughter in Auschwitz
and bore her home to Amsterdam
to be my occasional, indulgent boss.

You looked up at her in wonder,
a tiny woman, round as a robin
in a red fur coat
the colour of her hair
as, bobbing on her high heels
she did a little dance on the stones:
'Is this your daughter? Is this
your daughter? Let me look at her.'

Deutschland 1975

It was autumn, on walkabout in Bavaria.
Plum trees, pears.
With the last of my cash
I bought potato bread
and ate it with some *leberwurst*.

In Freiburg I fasted for three days,
lay on my back on the river bank
watching my island float far above me –
a dark shape in the blue vault.
Someday I would surface there.

In the hostel run by a one-armed Prussian
I met another journeyman,
a girl from Hamburg, aged fourteen.
I marvelled at her daring,
her empty blue eyes, the way
she was completely there.

I imagined her in the fourteenth century
in a flat-chested velvet brocade dress
being married off
to a creaking Teutonic knight
who took her to his Baltic castle
where, surrounded by Slavs and Letts
she would give birth
to a horde of men –
philosophers, warriors,
engineers and hunters.

On our last day
we said goodbye
on a bridge across the river.
She proffered her cheek to kiss
then she turned to the East.

The Hyperlocal

My mother's mother, the seamstress known as May, and her gossip and crony Mrs Kearney, are sitting in the parlour of Mrs Fox's Bar, Grocery and Undertakers, drinking brandy and peppermint at the mahogany table. They are wearing black astrakhan coats and holding large handbags on their laps. Their voices drop to whispers as they talk of land and pregnancies. I'm sitting in the window, drinking Coke and eating chips from the Valley Café as I listen to their murmurings,

watching the Blackwater river
spill its salmon
into the Boyne.

Rue des Irlandais

Up here on the mountain is the only place in Paris where the Metro doesn't mole beneath you. It feels like an island.

*

The streets around the Irish College are full of the gilded youth from Lycée Henri IV and the law faculty. Their skin has the sheen of wealth and power. Not many black or brown faces here.

*

I like to circle the mountain, walking down Rue des Irlandais, past the Hôtel des Grands Hommes, to cross the Rue Saint-Jacques. Glance right to see the Tour Saint-Jacques down the mountain, like the Dublin mountains at the end of Fitzwilliam Street. I plan my routes back and forth to include that vista. Then to the post office, passing the hotel where Marquez wrote *No One Writes to the Colonel*. I touch the brim of my hat to him and the other shades, of Rimbaud, of Miklós Radnóti, before I circle around and stop for a beer at La Montagne Sans Geneviève.

*

The Irish embassy on Avenue Foch, very French gilded sumptuousness. An Irishwoman from some foundation who is married to a French industrialist talks of the network of cousins and schools, how there are only 1400 families, and they control everything. The least social mobility of any European country. I told her about the *hôtel particulier* we had just visited, the ancestral home of Madame M, who showed us the portraits on the walls of her great-great-grandfather in his Thermidor hat, holding a musket, sword at his side.

The paradox of France. There is la France and la France. *Spleen et idéal*. Somehow, the two exist alongside each other. Is it too soon to call 1789 a success? The texture of everyday life is what you need to look at, like the old soldier in *Illusions perdues*, who unbeknownst to himself has come to embody Republican virtues. But he still has to move in the shopkeeper's world of the other France.

*

The old Irish College. In some ways it is the most Irish place I have ever been. At the concert in the church last night, a red-haired woman from Cork, long resident in Paris, singing *Oró sé do bheatha 'bhaile*. A feeling of *unheimlichkeit*. The ghosts were moving all around us, through the medieval streets. A time machine. Perhaps the Irish dream was born here, as much as in the peasant's bent shoulders.

*

Every day I pass the banally named Hôtel des Grands Hommes. Here Breton wrote *Les Champs magnétiques* in 1919. Increasingly I understand how surrealism changed everything for us. Automatic writing was not a gimmick, nor a technique, but a Luciferian lunge for freedom. Bonnefoy's eventual rejection of surrealism, his pained body language when he talked of André Breton, his former mentor. I think Bonnefoy thought that Breton was evil. Why? What is surrealism? Bonnefoy gives the example of the Max Ernst image, the man in the train with the head of a bird. Why shouldn't a man have the head of a bird? If God is dead, if nothing has any non-contingent meaning, then everything is possible, a man can have a bird's head, a urinal can be a work of art. Bonnefoy, I think, saw this freedom as ultimately diabolical, in opposition to the unity of being, the presence that lured him to the threshold. BUT on the other hand. Went to see Duchamp show at Beaubourg, found these words of his: 'I believe that the work of art is the only

form of activity by which a man can show himself to be a true individual, only through it can he transcend the animal state because art is a raid on the regions where neither time nor space rule.' Exactly. Freedom from time and space.

*

The amused Senegalese taxi driver refuses to believe that the street exists. Late at night we direct him around the Panthéon, to stop at the huge doors. 'I am an *Irlandais*,' I tell him, 'and this is my street.'

Centre Culturel Irlandais
November–December 2015

Bastille Day, Labastide, 2007

For Regis Huc

C'est l'azur. Tu n'as rien à craindre de l'azur. –André Breton

Azure is the luminous sky at dusk
With the sun hidden behind the black mountain
And the air is filled with the scent of *châtaignes*.
Above our heads *eoliennes*
Are dancing like dervishes down the hill.

Across the valley from Labastide, I watch
A dark rectangle of trees of a different green
Standing out against the forest.
I planted those trees, says Ernest Garcia,
Who walked here from Valencia in 1938.
That's where our vines used to be, says Regis,
I worked there after the war to make the family's wine.
How was it? I ask. Undrinkable, he says.
But that wasn't the point. You had to have wine on the table,
He says, even if you didn't drink it.
You had to have bread and wine on the table
When you sat down to eat.

Regis patrols the streets of the village,
Waters the flowers he planted in the intact casing
Of the bomb the Germans dropped on them
In July '44. The bomb missed, but they found
Their men soon after, machine-gunned them
Near the village of Trassanel, where we are standing
Now, in the hot sun and cold wind. On their stone monument
Thirty French names, and a couple of Russians,
Morts pour la France. Regis doesn't agree.
They didn't die for France, he says, they died for an idea.

But Regis, France is nothing if not an idea,
France is the dream in the peasant's bent shoulders
And the dream in Wolfe Tone's heart
When he stood in his blue uniform
On the deck of the ship in Bantry Bay
Seeing the Ireland which was to come.
France is bread and wine on the table.
France is the homeland that belongs to us all
No matter where we are born.
France is a shabby fortress
Where liberty doesn't need to hide her face.

And this is it: the ragged army of the republic.
Some local farmers, a few municipal workers,
A complacent official from Carcassonne,
And one old fighter, who survived,
Crawling away from the massacre
Drenched in the blood of his comrades.
Now he stands, crookedly erect, wrapped
In an oversized greatcoat,
Holding up the trembling tricolour flagpole,
His arm supported by a beautiful Arab girl
Dressed in the uniform of the *pompiers*,
Her hair as wild as an Irish thorn bush.
Under the azure sky, his voice,
Thin but strong, calls out,
As if for the first time: *Vive la France!*

Beuys

Watching through binoculars
I saw some bird of prey
windhover-like hovering in the air
wings spread, talons dropped,
looking straight down
into Jordi's takeaway valley
wondering what to order today.

I thought of a Stuka dive-bomber
specifically, the one called *Anton*,
which got detached from its squadron
and flew into a snowstorm,
crashing on the steppes
to disgorge into the future
– scorched, shriven, reborn –
the man called Joseph Beuys

who appeared years later
before my schoolboy eyes
on the Six O'Clock News
on our only TV channel
scribbling on a blackboard
about the secret person
at the centre of Ireland
where he would plant 7000 trees.

The black and white picture
kept fading into haze
as I fiddled with the rabbit ears.
Once, when they asked him
why he always wore a hat
he said: it's because I'm not a hare
and don't have hare's ears.

Falling

I always thought the dark
would just keep growing
till I was blotted out.
I hadn't expected this –

the way it's more like
being surrounded by walls
from which each day a brick is removed
so the light floods in, to dazzle you till

you fall, like Gaudí, cathedral unfinished,
struck by a tram and left to die,
mistaken for a tramp, maybe
recognised as such,

like Louis Kahn stricken
while shuttling between lives
on the yellow-stained floor of a restroom
in Pennsylvania Station

or Seamus Heaney, stumbling
on Leeson Street, shucking
off the dream of clay,
falling into light.

The Angle of the World

And the LORD shall scatter thee among all peoples, from the one end of the earth even unto the other ... –Deuteronomy 28:64

The only things moving on the street
(and when I say *street*, picture
the gorgeous Georgian thoroughfares
planned by the Wide Streets Commission
in seventeen fifty-seven –
the architecture of a people
with nothing to say, said Wittgenstein
as he passed through, depositing his case
in the world that was his Dublin hotel)

– the only things moving on the street
are the Boschian Brazilian cyclists
with boxes strapped on their backs
containing the food laced with chemicals
we seem to so crave.
They remind me of the Jewish pedlars
who disembarked from Lithuania
confusing Cork with New York,
to wander the roads of Ireland
with their backpacks full of threads
and other miscellaneous items.

I like to think that some of them at least
were engaged on a mystical quest
to prepare the Messiah's way
by scattering the divine sparks
to the very ends of the earth,
or *kezeh ha arez*, the Hebrew term for Angle-Terre
according to Menasseh Ben Israel
writing to Oliver Cromwell
seeking readmittance of the Jews.
The Census of 1891 showed
a single Jew living in Roscommon,
presumably engaged on the sacred work
of Tikkun Olam, to restore the fallen world
– and nowhere is more fallen than Roscommon.

Now we are seeing the world
as it has appeared to so many –
Godforsaken, void of people
an absence, a womb
of nothingness waiting to be filled,
what the Kabbalists called *tehiru*.
However, cleared of people
you can see the architecture better
– the architecture through which
now cycle the Brazilians.

I'm trying to work out what they're seeing
as their legs rotate the pedals of their bikes
breathing through the mask of a language
they can barely understand
with the street names occasionally mocking them
in a language they completely
don't understand.

My wife sometimes sends me down
to the *supermercado* on Capel Street
to score her favourite food:
she likes to eat the scooped-out hearts
of mighty palm trees, apparently.
I loiter in the shop,
thinking of Lin Yutang, who said
that patriotism was just an attachment
to the foods of our childhood
and how the Brazilians, just like us,
or the Poles, Moldovans and Russians
are addicted to the particular chemical formulae,
which make up their favourite
potato crisps and fruit juices,
their sucky sweets and weird chocolate.

Weirdest of all is the fact
that they sell imported water and charcoal.
The charcoal I can understand –
who *wouldn't* want his Dublin burger
permeated with smoky memories
of an Amazon forest?
But the water? What
is the taste of water?
Maybe it's something else,
maybe the sixty percent water we are
is calling out to its original maker,
wants to replenish
from the same source.

Back on the empty Georgian street
there's just me and the Brazilians.
I'm on my way to my dermatologist.
She scans my skin for cancer
while talking apocalyptics.
'You're Skin Type I,' she tells me,
'Celtic stroke Scandinavian.
All you Irish, your skin is too dry.
You should never go out in sunlight,
you're just not made for it.'
O back in the Ice Age we throve
with our melanin-less skin
slurping up the icy heat
till we were pushed out
to these dark edges
and here we are now,
burning up in the new sun.

If this were a movie
I'd show my seamstress grandmother
threading her Jewish needle

I'd show Oliver Cromwell,
steadfast on God's mission
marching across the bogs
west of Drogheda

I'd show the Brazilian cyclists
moving like insects
over the face of a corpse

I'd show Yuri Gagarin
bouncing out into space
and falling back again

I'd show my Bulgarian dermo
plucking lumps out of my back
and dropping bloody fragments
into a bowl near my face

Above all, I'd show a man
scanning the midlands' watery horizons,
waiting at the angle of the world.

Earthbound voyagers,
we sink our roots in water.

II

3 A...
OFF...
F/T COMM...
F/L G.D. BA...
N.C.O. ¾...
F/SGT. E...

Transpontine

My father died shortly before Christmas 2007. On Christmas Day my wife gave me a present of a book I had been coveting: Niall McCullough's *Dublin: An Urban History*, a magisterial examination of the plan of the city. In the following days as I read it and traced the lineaments of the city's plan through my memories of my father, it would become my ritual of mourning. *Dublin: An Urban History* would be my Tibetan Book of the Dead, guiding the soul to its new home, on the other side of the river: transpontine.

In recent years I have taken to cycling around Dublin, and I have discovered that cycling can be a kind of corporeal archaeology, history experienced through the body. As you cycle around the city, day in, day out, you become acutely aware of topography, of the dips and rises of the city beneath you, the actual physical layout of the city as it was long before the Vikings or Normans or Cromwellians set foot on it, the hills and hollows and sloping meadows, which once bordered the estuary.

The most common journey I take is towards the city centre from my home in Portobello. I cycle downhill along Clanbrassil Street in top gear, until suddenly I have to change down through the gears as I climb the mound where the city was first built, then freewheel down the steep side facing the river. According to McCullough, there has always been a crossing hereabouts, as ancient routes from the north and south of the country converged, long before the city was founded. The original Viking settlers – or Ostmen as they called themselves – established a suburb here on the north side of the river, opposite their city. A couple of centuries later the Norman invaders drove them across the bridge known as Pons Ossanorum to be exiles in the country called after them: Oxmanstown. The first Northsiders.

Another unexpected aspect is the way your body remembers as you cycle. When I cycle out to Finglas to visit my mother, it's easy-going as you plunge down into the Tolka Valley. But then, as I start the long, muscle-burning climb up to Finglas, my aching legs remember that this is a journey I traced four times a day for years, commuting from home to school in Glasnevin.

Increasingly, as I freewheel down the city hill to the river, a memory returns, which as far as I can make out is my earliest memory. It is dusk, probably winter, and I am in Dublin. I am sitting on the crossbar of my father's bike, a big black Raleigh. This memory is exclusively a visual one, and befitting the times, it is in black and white. It is Dublin circa 1960. It is a dark, smoky dusk, and we are cycling downhill towards the brown river. Those dusks are not an invention of the nostalgic memory of childhood – they are to be seen in photos and films of that era, the combination of burning coal and damp, the fumes of the nearby Guinness brewery. I can clearly see the mass of Christchurch Cathedral silhouetted against the sky. Then we are freewheeling down what I later came to know as Winetavern Street. Beneath the cathedral, falling down to the river, there is a jumble of buildings, which would later be demolished to create room for the new civic offices, one of the blights on the city, and the work of a truly banal architect called Sam Stephenson.

We are freewheeling down the hill, in the brown dusk, to fly across the bridge, over to the north side of the river. It is not difficult, even at this remove, to figure out where we are coming from and where we are going. My earliest memory of habitation was a house in Finglas, a new suburb to the north of the city. But I was always aware that this hadn't been my first home. I had been born in the Rotunda Hospital, on the north side of the river, but at the time of my birth my parents were living in a flat on Camden Street, on the south side of the river. Why they were living there I have no idea. It must have been something of a rundown area at the time. Behind the

street there were slum dwellings, little courtyards of decrepit cottages. At the end of the street was the district of red-brick terraced houses known as 'Little Jerusalem'. A few doors down from the flat was a building, which had briefly been a synagogue and then the headquarters of the International Tailors, Machinists and Pressers Union, founded in 1908 by Jewish immigrants from Eastern Europe. But it had closed down long before 1958, the year of my birth. The district had changed its character as the Jews left for the more salubrious suburbs of Terenure and Churchtown, leaving behind a hard core of the native working class. By the end of the century, however, a new wave of journalists, academics, artists and immigrants, particularly from Islamic backgrounds, would transform the area all over again. When I first moved into the area, the ground floor of my former home in Dublin was a Polish supermarket where I bought pickles, sauerkraut and rye bread. Now, it's a Palestinian restaurant called Jerusalem.

It still seems an unusual choice, as my father's family were deeply rooted in one particular corner of the north inner city. Just over the bridge, in a tenement on Mary's Lane, my grandmother had been born, the daughter of a pig dealer, one Jem Reilly, who kept a piggery on the site of what would become the Motor Taxation Building. The nearby fruit and vegetable markets provided a steady flow of waste food for the pigs. My grandfather lived nearby with his mother and grandmother on North Brunswick Street, near the corner with Church Street. My great-grandfather had abandoned the family soon after his son's birth and moved to Birkenhead. He died in Passchendaele in 1917. Patrick Nolan, my great-great-grandfather, a malter from Wexford, lived at 5 Beresford Street East, literally inside the enormous malting house. When my grandparents married they moved a couple of yards from their respective homes to Coleraine Street, a row of terraced houses facing decrepit Georgian tenements. The name derived, according to McCullough, from the provenance of the merchants who used the nearby linen hall, one of the city's medieval centres, which was long destroyed.

More importantly, the area was dominated by Jameson's Distillery, its manufacture and warehouses. My great-great-grandfather, great-grandfather and grandfather had all worked there, as would my father. Here also were the various fever hospitals, where my father would spend long periods. It was natural for the family, I suppose, to gravitate around this area. Even though technically I was a parishioner of Haddington Street Church on the South Circular Road, my grandmother insisted I be baptised in her local church, St Michan's, on nearby Halston Street.

I became familiar with the area as a child. When I was four I demanded to go to school, but there was none available in the newly built suburb, so every day I had to take the bus into the city. The number 34 bus took me down Church Street past the original St Michan's. This was an early lesson in being Irish. St Michan's was the first church on the north side of the river, built in the eleventh century. Its vaults contained the preserved bodies of Crusaders. And yet, even as a child I understood that I had been baptised in the other – the real, the Catholic – St Michan's, a couple of streets away.

My grandmother would collect me from the bus and walk with me the hundred yards to my first school on Strand Street, now demolished and replaced by an apartment block. The only thing I can remember about it is being struck in the face by a teacher for some minor transgression. I can't remember feeling pain but I do remember the resentment, the anger, the desire for justice.

As we walked along to school we would pass the Four Courts with its imposing dome, the seat of justice in Ireland. In 1922, during the Civil War, it had been occupied by Republican forces, and was bombarded by the Free State army from guns placed at the bottom of Winetavern Street, firing over open sights across the river. At that time my grandmother was working in Jacob's Biscuit factory. She told me later on how, as she and her friends came home from work, they would have to crawl on their hands

and knees across the bridges to get to their houses in order to avoid the rifle and artillery fire of the two nationalist factions.

All of this reinforces my snapshot on the bicycle. As we lived on Camden Street it would have been natural for my father to commute regularly back and forth across the river from there to Coleraine Street where his mother, the controlling matriarch of the family, lived, and where he occasionally worked in the distillery in nearby Bow Street. Jameson's, like Guinness, was a patriarchal company. The children of its workers tended to work there in their turn. Like Guinness it was considered to be the holy grail of the inner-city working class. Permanent jobs with privileges and perks – in a difficult world of unemployment and poverty it offered sanctuary. Eventually my father became a permanent worker and he stayed there until he retired in the 1980s. It was not a future anyone would have predicted for him.

He had left school at a very young age and worked at all kinds of things. At the age of seventeen he followed his elder brother into the Royal Air Force, taking the train from Dublin to enlist in Belfast. The RAF left its mark on him. All through his life the RAF represented some kind of lost Eden to him. In recent years there has been much talk of Asperger's and the military, and I always suspected my father of some mild form of this autistic condition. It would fit his profile to thrive in such conditions. He loved the discipline, the general sense of order; he was the kind of man who seldom left the house without giving his shoes a quick polish. He loved the slang. On one occasion I brought a girlfriend home to meet the family, and after she left my father asked: 'What's the gen on that bint?'

He was almost militantly pro-British; his loathing for the British officer class, or 'the chaps', as he sardonically called them, was based on class rather than national hatred. He admired the English for their stiff upper lip, their brisk tolerance, lack of religiosity, their no-nonsense approach. For the rest of his life he would be a confirmed Anglophile. He read the *Sunday Express*

every Sunday and on Christmas Day would insist we watch the Queen's speech on TV, which occasionally moved him to tears. 'She's a lady,' he would say, his highest words of praise for any woman. Somehow he left the RAF and returned to Ireland, though for a long time I didn't understand why. It was only on the day of his funeral that his brother told me they had deserted when threatened with being sent to Malaysia to put down the Communist insurgency.

As far as I can make out, some years after leaving the RAF, he drifted back to London and worked in various restaurants, including that of the Ritz. He seemed to have loved this, as indeed, he seemed to have loved London. Sometime in the fifties he started working as a cook in Butlin's holiday camps. He was working in the strangely named Pwllheli, in Wales, when he met my mother. My mother was a 'Redcoat', the hostesses who made sure everyone was enjoying themselves. This marriage was something of a solecism for my father's family as all of his brothers and one sister married people from Dublin – in many cases from their own corner of the city. My mother, on the contrary, came from a small farm set in the idyllic green fields and woods between Navan and Kells, only thirty-five miles from Dublin, but a whole other universe. They honeymooned in Snowdonia, and returned to Dublin before my birth in the Rotunda hospital.

One aspect of this story doesn't make sense. The late 1950s was a dreadful time to return to Dublin: unemployment, misery, despair. People were, on the whole, leaving. Why did my father return? I never asked him, and he wasn't the kind to disclose meaningful information. This curiously contingent aspect of my birth would later cause me much speculation. What if they hadn't moved, and I had been born in London? Would I have become Ian Duhig? Shane MacGowan? Or just another Plastic Paddy? I suppose this predisposed me to see nationality and ethnic identity as purely arbitrary.

However, for whatever reason, he returned home, to Camden Street. With family connections he managed to get seasonal work in Jameson's Distillery. He went to work in the Malthouse, as they called it. My grandfather was still alive, but he was a sick man, coughing his lungs to shreds, until he died at the age of sixty-one in the old Meath Street Hospital, yards away from our home on Camden Street. Romantically, he had acquired his weak chest by refereeing a football game in dreadful weather. He had been an outstanding athlete in his youth, winning three football caps for Ireland. I had often heard it said in the family that it was his footballing ability which kept him out of the front line during the First World War. I barely remember him. My parents seemed to settle into the pattern of migrant workers. In the winter my father worked as a casual labourer in the distillery, and in the summer both my parents worked in the holiday camps in England and Ireland. There are many photographs of me in holiday camps, seated in fairground cars and rides, glumly enjoying myself. In later years the Irish one at Mosney, where they often worked, would be turned into a so-called direct-provision camp for asylum seekers. These camps had been the Zion of the working classes of Ireland and England, full of sunshine and laughter, life and light for the children of the crowded tenements and drab suburbs of Dublin. Now, lashed by the wind and rain of the Irish Sea, they offer a different kind of hope.

Two years after my birth, my father will pedal hard up the hill with my extra weight. Pausing at the top, he will see below him Winetavern Street and the bridge. We will pass the Four Courts on his left, go down Beresford Street and turn into Coleraine Street. We pass under the cathedral arch and freewheel down the hill.

Before I know it, we will be on the other side of the river.

Liberty Hall

A film poem

Memory itself is a form of architecture. –Louise Bourgeois

... the new palaces, scaffolding, blocks,
the old neighbourhoods, for me
all turn into allegory
and my memories are heavier than rocks. –Charles Baudelaire

*

Out of this building our army marched
to join the Greencoats in the GPO
next door to the Metropole Ballroom
where, forty-odd years later
my parents would waltz me into being.

Late at night I squint into a tiny screen
trying to spy on my parents' romance,
watching Fred Astaire, how
he danced with Ginger Rogers
and Cyd Charisse.

I imagine what they were like,
cosplaying Richard Burton, Elizabeth Taylor,
he certainly as sardonic, she
just as beautiful, the dresses,
the suits, the cigarettes.

On her wedding day
she stood on the pavement
outside the Meath Street Hospital
to show herself to my father's father
dying, contagiously, inside.

Every day now I walk that potholed street
and look up at the dusty windows
where sometimes I think I glimpse him,
liminal as Harold Bloom's
gnostic psyche

and it's as if I'm looking down
at his pale tubercular face
like a painting I saw of a drowned
Syrian refugee, stepping
through a blue door.

He never got the button job as promised
but laboured in the Malthouse.
Jameson's and Guinness's
the twin liquid nirvanas
of the Dublin working classes.

*

Brendan Behan died in this same hospital
his heart exploded by alcohol
– child-bomber, marginal magus,
pure intelligence
corrupted by culture,

he staggered through my childhood.
Once the teacher told my class
that Behan's job was a painter,
not like Leonardo Da Vinci though
– he painted houses.

(The Free State painters: a regiment of men
who set out armed with buckets and brushes
to paint the postboxes, reversing
Shakespeare's multitudinous incarnadine
to make the red one green.)

*

I watched a lot of movies with my Da.
Our favourites were Westerns and what
I didn't know then was called film noir,
John Wayne, Bogey, Lauren Bacall ...
as the credits rolled my father would toll the bell.
He's dead. She's dead. He's dead now.

Dead like Frank Deasy,
my apple-picking accomplice
in Danish orchards. At night
he passed like a psychopomp
through the police cordons

around the brutal utopia of Christiania
with little packets of hash
safety pinned inside the bells
at the bottom of his bell-bottomed trousers.
In the 1980s he and Joe Lee

made a flick, which has Gabriel Byrne
moving through the stricken city
overshadowed by Liberty Hall.
When I told the actor about this poem he said:
'I thought they were knocking it down.'

Looking down the river
towards the sea
I realise I'm becoming nostalgic
for a column of air,
which doesn't yet exist.

Crossing the River Liffey
from South to North
irony grows faint,
withers away
like Engels' imagined state.

*

'My Mother in the Cloud'

From my desk I see the black clouds
drop onto the Northside
over beyond the river
behind the cranes, and spires
of Christchurch and the Dean's.

Over there is my mother.
The phone rings:
I'm sitting in the car outside SuperValu
and the hailstones are hopping off the roof
thank God for the sup of rain it was badly needed.

*

'Pangur Bán'

The red-brick suburbs surround me,
seething with cancer and foxes.
Late at night my dog and I
patrol these sombre canyons,
eagerly sniffing our prey.

*

'Auschwitz'

Along the banks of the Grand Canal
the Poles are angling for pike and perch
in the Republic's open veins
which empty into the black pool
spreading beneath our feet.

'A Short History of the Irish Navy'

Yeats, Shaw, Joyce, Beckett ...
catalogued and ossified
in the antediluvian zoo
– rebranded as ships and bridges
under which the city's quick
brown life discreetly floods.

Liberty Hall was destroyed
by the gunboat *Helga*
using two QF 12-pounder 12-cwt guns.
In 1923 she joined the Free State navy
under the name *Muirchú*.

(The LÉ *Samuel Beckett* is equipped with the following: the Italian-made naval gun OTO Melara 76mm, the German-made Rheinmetal Rh 202 Autocannon, the American-made M2 Browning.50 heavy machine gun, the Belgian-made FN MAG machine gun, the Austrian-made Steyr AUG assault rifle and the German-made Heckler & Koch USP semi-automatic pistol.)

*

At the end of the street they hover
like fallen constellations,
a host of metal herons,
light-fingered pterodactyls
tearing at the old town's entrails.

*

'After Alexander Blok'

Night. Street. Streetlight. Pharmacy.
The light dull and meaningless.
Live another twenty-five years
it'll all still be there. No way out.

You die, and start all over again.
Everything repeats itself.
Night, the cold shudder of the canal.
Pharmacy, street, streetlight.

Canal. Brothel. Russian Church.
My home in Amsterdam
was shoehorned in between them.
On Sundays I could hear the Mass being sung
ten feet from my pillow, the choir
behind a single layer of brick

– the magic of brick,
the way it creates metaphorical spaces
coincident with the concrete ones –
how the buildings we move in
mirror our lives!

My first home is just a few streets away
from this one, above what was formerly
Stein's Travel Agency. In the Nineties
it became a *Polski sklep*, where I went
for pickles and sauerkraut, beetroot
and kefir. Now, it's the Jerusalem restaurant.

Across the canal in Harold's Cross Park,
where the gallows once stood, two popes
loll in the autumn sun,
drinking lattes, their jeans
showing under their cassocks.

After Mass the café is full
of tall Russian girls
in Sunday best – flowery knee-length skirts,
in textiles I haven't seen since Riga,
straight blond hair tied back.

From my window I can see
their Church of Peter and Paul,
while downstairs, two Brazilian girls
are offering the best
ungrammatical massage from Dublin.

*

From my father's grave
you can see the new Lidl.
Like me, he loved supermarkets.
I sometimes just walk the aisles
and leave without buying anything.

He ate bread with every meal,
even if he wasn't hungry.
How many generations does it take
to purge the fear of hunger,
fear of dispossession?

In my parents' wardrobe
I found his battered old briefcase,
stuffed with papers on labour law
and memos from meetings at Liberty Hall.
Somehow, he had lost it.

Did he ever dream
of what it must be like
to dance like Fred Astaire,
weightless as an astronaut?

*

Megrim of memory and meaning …
I dreamt my wife had challenged me to sing
in front of an orchestra, something
by Purcell, maybe the Cold Song.
I opened my mouth and out came nothing at all.
This is me singing. This is Liberty Hall.

Appendix: Meridian

Dublin and Amsterdam (1991)

I am looking for all of this with an unsteady and thus probably inaccurate finger on the map – on a child's map, as I should admit outright ... None of these places can be found, they do not exist; but I know, and now especially, where they ought to exist, and ... I find something! I find a Meridian. –Paul Celan (trans. Michael Hamburger)

I

'The whole world is suburb,' wrote Marina Tsvetaeva. 'Where are the real towns?' As someone who grew up in a suburb on the extreme edge of a city on the extreme edge of Europe, it was natural that the same question should always have obsessed me. In childhood I was always acutely aware of being on the *edge* of something. The city of Dublin was our capital, around which we were centred. And growing up was a process of getting to know that centre, that place known to Dublin buses as An Lár. But in my search for that – in one sense, of course – inevitably illusory centre, I soon became aware of certain shortcomings in Dublin's claims. I felt that Dublin did not satisfy my search for centrality, but it took me a long time to understand why.

There were some perhaps overly obvious reasons. Dublin was the capital of Ireland, but the official culture of the country was indifferent and even hostile to urban traditions and urbanism. Inevitably this led to a kind of cultural schizophrenia, and restricted the growth of certain aspects of urban culture in Dublin. There was hardly any other sense in which Dublin could claim to be a capital. Since independence in 1922 the Irish government and the Irish people they represented had done no more than squat in the city and slowly reduce it to

ruins. The peculiar self-hatred of Dublin, which was so evident in episodes like Wood Quay, were symptomatic of a deeper problem. At the centre of Dublin, it seemed to me, there was literally and figuratively an emptiness, a lack of sustaining tradition. Again, this is not an entirely negative thing, as it does induce a pleasant feeling of weightlessness, and bestows a kind of freedom. But this feeling would be incomprehensible to a Roman, say, or a Parisian.

However, there was an even deeper problem, a feeling whose consequences are more profound. In a conversation on Romanesque architecture with the French poet Yves Bonnefoy, Paul Celan – the German-speaking poet resident in France, who had been born in what had been the Austrian-Hungarian empire, then Romania, and was now the Soviet Union – complained to Bonnefoy: 'You [meaning French or Western poets] are at home, inside your reference points and language. But I'm outside ...' Being Irish is to be born susceptible to the same feeling. Not that this has always appeared as something negative to me: after all, for a poet, displacement and alienation, the sense of being both inside and outside a culture, are money in the bank! It could be argued, in fact, that Celan is far more 'inside' the new European culture than Bonnefoy, weighed down by French culture, could ever be. This feeling has also been well defined by Witold Gombrowicz in his writing about Poland, where he speaks of countries like Poland, Holland, Romania etc. as being secondary European cultures. He defines these as countries where the main thrust of European culture has never really penetrated.

Of course, there was another sense in which Dublin was indeed a cultural capital, a capital of the European imagination, figuring huge on that surrealist map of the world, which had excluded the island of Britain altogether. But that argument did not satisfy me then, and still doesn't. If Dublin can lay claim to this title of cultural capital, it is because of the individual effort of Dubliners; and from a city, by definition, you can expect

something more than that. Joyce implied that he was his own creation, and it seems to me questionable to claim as a virtue what was necessity.

But none of this was a problem. If Dublin was not the centre, the cultural capital I was looking for, it surely existed elsewhere. It seemed to me that a cultural capital could be defined as the place where, once you have arrived, you want to go no further. Mandelstam's definition of Acmeism as 'nostalgia for world culture' encapsulated perfectly my vague feelings. But as much as I felt myself drawn to that imagined centre of a provisional cultural capital, I was inevitably disappointed. There was one major reason for this. Like many Irish people, I believe, I had failed to understand just how crucially the Second World War had maimed not only the physical Europe, but the Europe of the imagination. The cultural capitals no longer existed as I had imagined them. I was thinking in terms of Vienna before the Great War, that laboratory for the end of the world, of Paris between the wars, and Berlin. But these cities had changed: despite the superficial European-ness imposed after 1945, there was a terrible withdrawal into national cultures. That was what struck me most strongly: Paris was too French, Barcelona too Catalan, Amsterdam too Dutch, to be real capitals of Europe. Where were the international magazines? Where was the cross-cultural avant-garde? Where were the real towns? Beckett may now appear a loner, but he did not begin like that. It could be argued that New York became the true European cultural capital after the war, a process which had begun years before when Duchamp, Schoenberg, Broch and all the rest had headed west. The problem with New York, however, is that it is also the American capital.

The problem was that these cities were no longer cosmopolitan enough. And lack of 'cosmopolitanism' in the sinister, Stalinist sense, was precisely the problem. Europe after the war was different to Europe before the war. Once, when George Steiner was discussing with his father the possibility of taking up a

proffered post in America, his father told him: 'If you take that job, Hitler will have succeeded.' But unfortunately there is a sense in which Hitler did succeed. Hitler himself said that the destruction of the European Jews would be seen as his most important achievement. And it was. By destroying, to all intents and purposes, European Jewry as a force in European culture, Hitler gave European culture a frontal lobotomy. The significance of the Jews, I need hardly add, lay not in any 'racial', religious or cultural content of their presence in a particular culture, but in their otherness. With the imposed shifts in population and the settling of accounts with regard to minorities that went with the redrawing of borders to ensure more politically and culturally unified states, each country was left to stew in its own homogenous juices. The great European cities, those fluid test tubes of the spirit, were shut down. It was as if each country, in a state of shock from war, needed to close itself off and retire to an easier, more comfortable mode of being. Cities like Warsaw became the grey capitals of racially and culturally monolithic states, recalling the stifling nightmare of the Irish Free State and later Republic. There would be no more Kafkas and Rilkes in Prague. The 'Europe' invented after the war was necessary because real European unity had simply disappeared or moved to America. Henceforth there would be no more European capitals, merely the provincial headquarters of nation states.

II

In the end it was other, more pragmatic factors that brought me to live in Amsterdam, a city which never figured in my dreams of a European 'centre' or 'capital', though it might have. To begin with Amsterdam seemed to me a textbook example of the process I have just described. On the face of it, it could lay claim to being a cultural capital on the basis of the sheer volume of 'culture' it contained. It had orchestras, operas, ballet companies, museums stuffed with old masters, a city centre, which was itself a well-preserved work of art. On his first visit to Amsterdam my father remarked bitterly: 'None of this would have been a patch on Dublin.'

And indeed, all this formed a painful contrast with Dublin, a city of roughly the same size. Of course Amsterdam was laying the foundations for this when 'A nettle-wild grave was Ireland's stage' and it was all too easy to fall into stereotyped antitheses: Amsterdam was presence where Dublin was absence; Amsterdam was culture where Dublin was art. The connection between cultural capitalism and wealth was brought home to me with enormous force. After all, Amsterdam was the first city founded for the express purpose of making money, and certain forms of culture depend almost entirely on surplus wealth. Without this there are no museums, no world-class orchestras, no gleaming new opera houses. Yet all this culture failed to make it a capital. It was too Dutch, too inward-looking, and this – coupled not at all paradoxically with a slavish adaptation of anything coming from America – disqualified it. Amsterdam, perhaps unfairly, struck me as a city squatting cosily in the still-sumptuous mantle of posterity. Sometimes, in the damp, icy winter evenings along the canals, when the tourists are at home and the illuminations are turned off, the city appeared to have something grotesque, tomb-like. But I wasn't able to clarify my feelings about this until I saw Lanzmann's film *Shoah*. One of the most moving images of the film is the sequence of images of everyday life – a garage, a block of flats on the site of the ghetto in Warsaw. And of course, Amsterdam was suffering from the same effect.

Before the war, there were more than a hundred thousand Jews in Amsterdam; after the war, a mere ten thousand were left. A flavour had gone out of the city. Of that diamond city of merchants and philosophers, cafés and cabarets, there was little left except a few semi-derelict synagogues and scattered Yiddish words in the Amsterdam dialect, like the phosphorescence of the dead. In Amsterdam, this forced retreat into a homogenous Dutchness was exacerbated by the very understandable reaction against its natural hinterland of German language and culture after 1945. In a sense, Amsterdam was now culturally orphaned, and increasingly disposed to the bland embrace of a superficial

'internationalism'. A hundred yards from my house, on the site of the old Jewish entertainment area of theatres and cabarets, there was now the cavernous Escape disco, from which MTV was broadcast to the homes of Europe, presenting another view of European unity.

At this stage it seemed to me, and to many other people, that the only city which could claim to be a real European capital was that dark blue angel hovering over Europe – Berlin. Artificially created, artificially sustained, it was a city without a country, a city in which people sought refuge from countries, where the medieval myth of the city as the place that makes free was still preserved: a capital disguised as a frontier post.

III

I was wrong in my judgement of Amsterdam. It gradually became clear to me that Amsterdam, or an aspect of Amsterdam, was precisely the centre I had dreamt of in the suburbs of Dublin: a boring, perfectly satisfactory utopia. What were the components of my imaginary capital? One of them was certainly a sense of civic life, civic responsibility, a consensus. A city where people elect to live in order to enjoy certain mutually agreed freedoms. All the old virtues of the city, with the modern twist that it involved the greatest good for the greatest number: in short, that purely European urban phenomenon, that way of dwelling in the world anything but poetically, which is called social democracy – two words that induce a mental yawn. My nostalgia for this kind of society was bred into me – directly attributable to my Dublin background, that of the industrial working class – with an almost religious adherence to trade union values. A matrix of beliefs, which was the norm in Europe, but in Ireland had the status of an exotic sect, like Marranos under the hegemony of Irish Nationalism, the official state religion. This set of values, I hasten to add, was not necessarily opposed to Irish nationalism, particularly in its Republican avatar: it simply dwelt in another universe. And it became clear that these kinds of values were at the basis of Dutch society, even if some of the Dutch themselves

had forgotten it. In Amsterdam, if you look carefully enough, you can find that Jerusalem, that dull, unexciting utopia.

As Auden said, 'a change of heart' is invariably accompanied by 'new styles of architecture', the grammar in which cities express their innermost selves. A short journey by tram from the city centre of Amsterdam is a suburb with the poetic name of Betondorp (Concrete Village), most famous as the birthplace of the footballer Johan Cruyff. There is nothing special about the place. It is a modestly experimental suburb built in the 1920s, notable mainly as an early example of the building of houses in concrete.

But that is what is remarkable about it. In the 1920s, in Amsterdam, the best minds, the best architects, town planners and administrators in Holland at that time, were given the resources to build a place for people to live in, which would allow them to live full, healthy lives. Every aspect was taken into account: where the church would have stood in a village there was a library and reading room for self-improvement. There is for me something tremendously moving about it. It is not as spectacular as some other citadels of social democracy, like the Karl Marx-Hof in Vienna, but in their own way, these suburbs of Amsterdam are Delphis, the modern equivalent of Versailles or Newgrange, and the Dutch are inexplicably modest about this magnificent tradition. Because the philosophy expressed here is the hidden creed of modern Europe. The idea of social answerability and the responsibility of a society to its citizens, over and above the free play of market forces. The idea that built these houses is an idea which has yet to assert its dominance in Irish society, which I first became conscious of as an absence. It is also the idea which implicitly and sometimes explicitly has fuelled the changes in Central and Eastern Europe. In an important sense the revolt there was a victory of the suburbs over the centre. The dream was not of a new polity, but the suburban, social democratic one of house and garden, cars and well-stocked supermarket shelves – and freedom to enjoy them.

The medieval Axis Mundi, or Paul Celan's Meridian, now runs through the suburbs. The young people protesting in Berlin against German unity were protesting at their dispossession, the victory of suburbia, which would make them homeless, gypsies once again, because with unity, Berlin became just another bland European capital city, thoroughly German as Paris is French.

IV

Where does Dublin figure in this? On the one hand, if the suburb, almost indistinguishable from country to country, is the true cultural capital of our time, then Dublin, *nolens volens*, is obviously included. On the other hand, the eclipse of the cultural capitals of the primary cultures, like Paris or Berlin, and elimination of that distinction between primary and secondary, which will be accomplished by a new European order, means that everything is up for grabs. A new cultural order is set to emerge in Europe, the shape of which no one can even guess at. And yet it might be reasonable to expect that Europe will once again become the 'continent of energetic mongrels', and that the 'new' Europe (as if that were not a contradiction in terms) will first make itself felt not at the superseded 'centres' but at the cutting edges of the new empire, the frontier posts. I would go as far as to say that the essence of a cultural capital is an indifference to being a capital of anything so banal as a nation state. And if this is the case, we can expect Dublin to start the race with a low handicap.

Acknowledgements

Some of these poems first appeared in *The Irish Times* and have been broadcast on RTÉ Radio, to whom acknowledgement is gratefully made.

'Leonard Cohen' was commissioned by Martin Doyle, literary editor of *The Irish Times*.

'Bastille Day, Labastide, 2007' was commissioned by the Embassy of France in Dublin to mark Bastille Day 2017 and acknowledgement is gratefully made to HE Stéphane Crouzat.

'Transpontine' was first published in *The Globe and Scales*, edited by Jake Regan and published by Marrowbone Books.

'Meridian' was commissioned by Richard Kearney to mark Dublin's year as European Capital of Culture 1991, and published in *The Irish Review* in its Spring 1991 issue.

Special thanks to Nora Hickey M'Sichili and her staff at the Centre Culturel Irlandais, Paris, and to Kateřina Bajo and her staff at the Prague UNESCO City of Literature, and to John McHugh and the Achill Heinrich Böll Association.

Image Credits

23 Max Ernst, 'The Birdman in a train carriage passing a sphinx which is being attacked by mice'. First published in *Une Semaine de bonté ou Les sept elements capitaux*. (*A Week of Kindness or the Seven Deadly Elements*). © Artists Rights Society (ARS), New York / ADAGP, Paris.

30 Joseph Beuys, 'The Blackboards, Dublin 1974'. Collection & image © Hugh Lane Gallery. © Estate of Joseph Beuys, DACS London / IVARO Dublin, 2021.

33 Hieronymus Bosch, 'The Pedlar' (1490) © Peter Horree / Alamy Stock Photo.

42 Kevin O'Loughlin in RAF uniform, circa 1947. Courtesy of the author.

50 Still from *The Courier* (Joe Lee / Frank Deasy, 1988). Courtesy of Joe Lee.

54 Brian Maguire, 'Over Our Heads the Hollow Seas Closed Up' (2016). Courtesy of the artist and the TIA Collection.

67 'Surrealist Map of the World', artist unknown. First published in an issue of *Variétés*, Brussels, 1929.